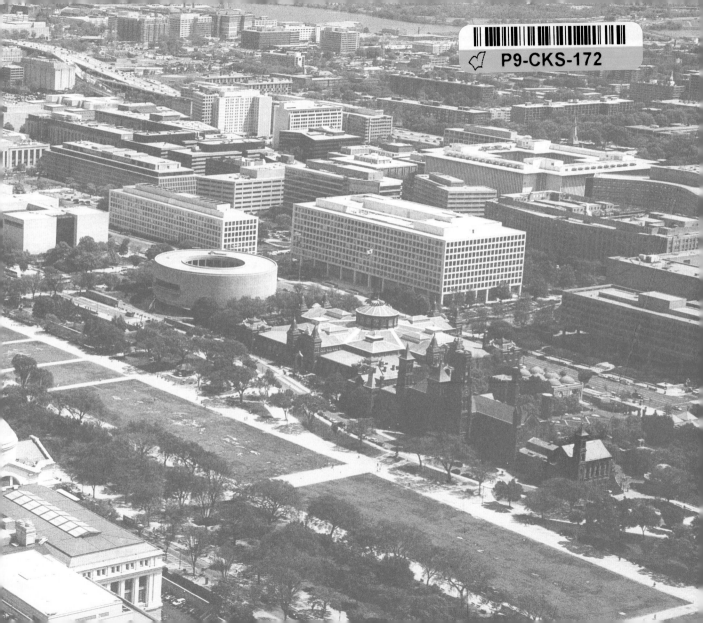

Smithsonian Institution

A PHOTOGRAPHIC TOUR

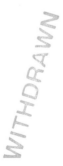
SMITHSONIAN BOOKS, WASHINGTON, DC

Published by Smithsonian Books
Carolyn Gleason, Director
Christina Wiginton, Editor
Michelle Lecuyer, Editorial Assistant

Text and photo research by Amy Pastan
Design by Bill Anton | Service Station

Special thanks to Smithsonian photographers Ernest
Amoroso, Jessie Cohen, Chip Clark, James DiLoreto,
Mark Gulezian, Donald Hurlbert, Walter Larrimore,
Eric Long, Mehgan Murphy, Ken Rahaim, John Steinen,
and Hugh Talman for their contributions to this title.

Library of Congress Cataloging-in-Publication Data
Smithsonian Institution.
Smithsonian Institution : a photographic tour.
 p. cm.
ISBN 978-1-58834-301-7

1. Smithsonian Institution–Pictorial works.
2. Museums–Washington (D.C.)–Pictorial works.
3. Washington (D.C.)–Pictorial works. 4. Mall,
The (Washington, D.C.)–Pictorial works. I. Title.

Q11.S8S69 2011

069.09753–dc22 2010039633

First edition
16 15 14 13 12 11 5 4 3 2 1

Printed in China through Oceanic Graphic Printing,
not at government expense

Smithsonian Books titles may be purchased for
educational, business, or sales promotional use.
For information please write:

Special Markets Department
Smithsonian Books
P.O. Box 37012, MRC 513
Washington, DC 20013-7012

FRONT COVER: North entrance of the Smithsonian
Castle seen from across the National Mall

BACK COVER: South entrance of the Smithsonian
Castle seen from across the parterre of the Enid A.
Haupt Garden

END SHEETS: Aerial view of the National Mall looking
east. Photographed by Carol Highsmith, courtesy of
the Library of Congress.

OPPOSITE: Silhouette of the Smithsonian Castle seen
against a spectacular July 4th fireworks display on
the National Mall

THE CASTLE English scientist James Smithson never set foot in the United States of America, but he bequeathed his fortune "to found at Washington under the name of the Smithsonian Institution an establishment for the increase and diffusion of knowledge." Smithson's gift is now the world's largest cultural and scientific complex, with an extraordinary network of museums, research facilities, and libraries. The historic Castle welcomes visitors.

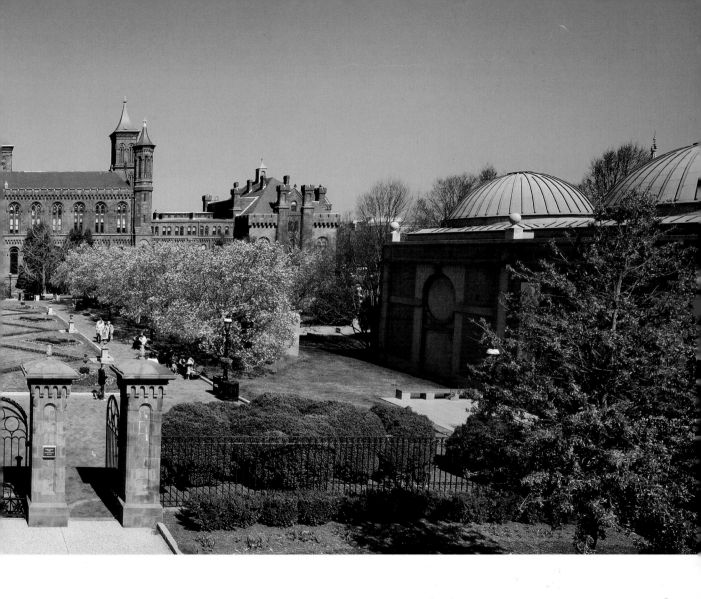

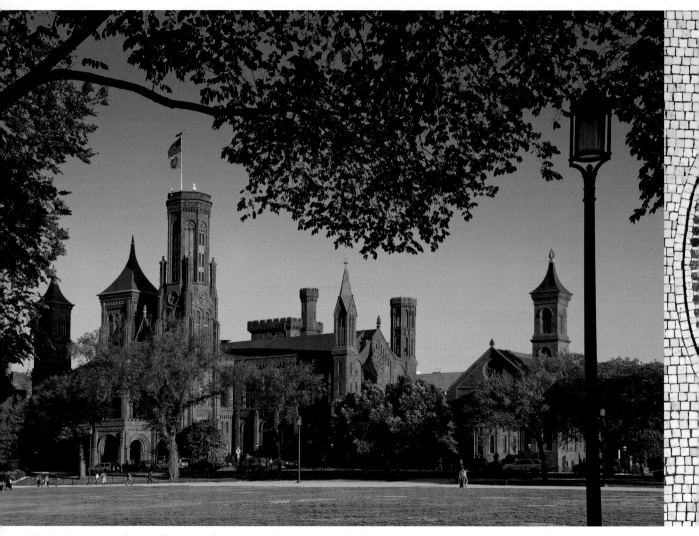

The Smithsonian was chartered by an act of Congress in 1846. The original building, known as the Castle, was designed by James Renwick and completed in 1855. Its Gothic façade, made of red sandstone, stands out on the National Mall. It is not only a symbol of the Institution but of Washington, D.C., itself.

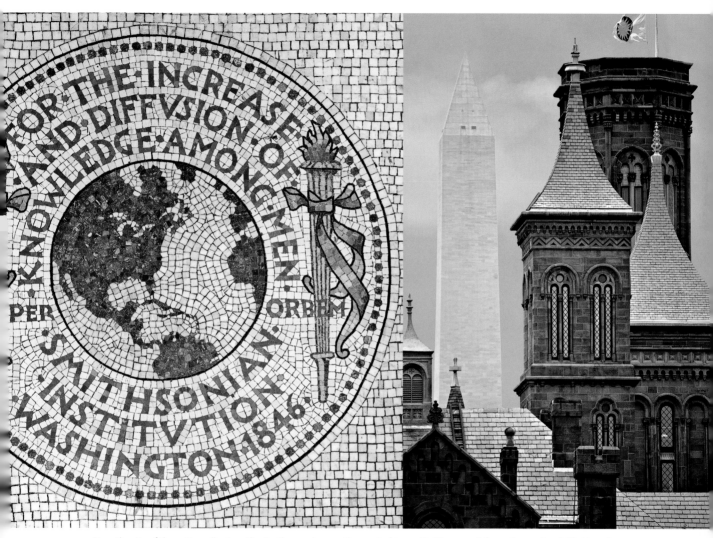

RIGHT TO LEFT: Once the site of the entire collection, the Castle now houses the crypt of James Smithson, an information center staffed by volunteers, and offices. A decorative mosaic set into the Castle floor commemorates the Institution's founding and its ambitious mission.

NATIONAL AIR AND SPACE MUSEUM One of the most popular sites in Washington, D.C., the National Air and Space Museum's galleries showcase the spectrum of flying machines, from the 1903 Wright Flyer to SpaceShipOne. IMAX® films convey the thrill of flight, and programs at the Albert Einstein Planetarium connect viewers to the universe.

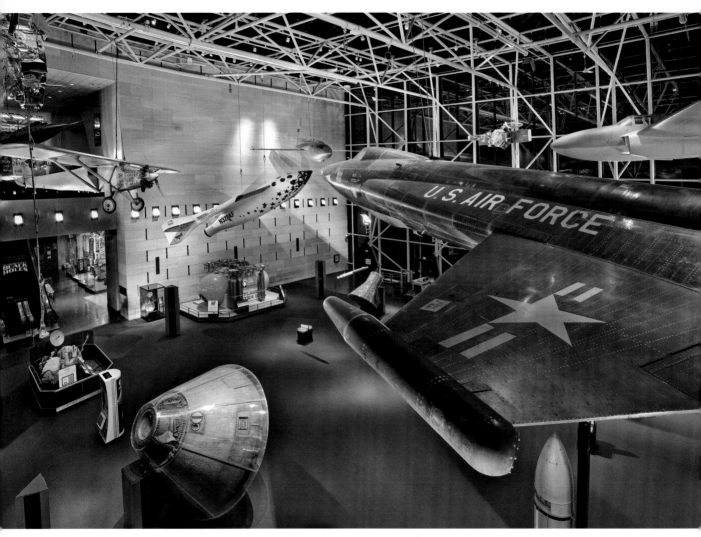

The first gallery inside the entrance is *Milestones of Flight*, featuring the fastest aircraft ever flown, the North X-15 (foreground), Charles Lindbergh's Ryan NYP *Spirit of St. Louis* (upper left), SpaceShipOne (center), the first privately built and piloted vehicle to reach space, the bright red Breitling Orbiter 3 Gondola (floor, rear), and the Apollo 11 command module (floor, center).

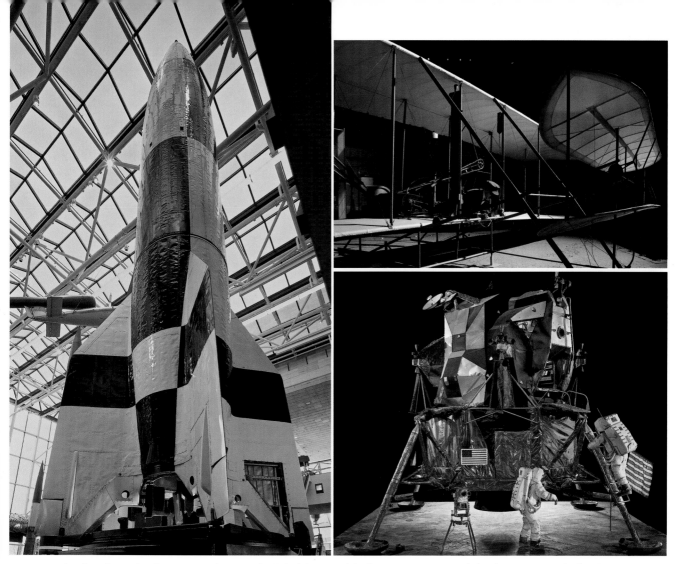

CLOCKWISE: A gallery devoted to the space race between the United States and the former Soviet Union includes this German V-2, the first long-range ballistic missile. The 1903 Wright Flyer was the first aircraft to make a sustained flight and is in its own gallery on the second floor. Lunar Module 2 was used for ground testing prior to the first successful Moon-landing mission.

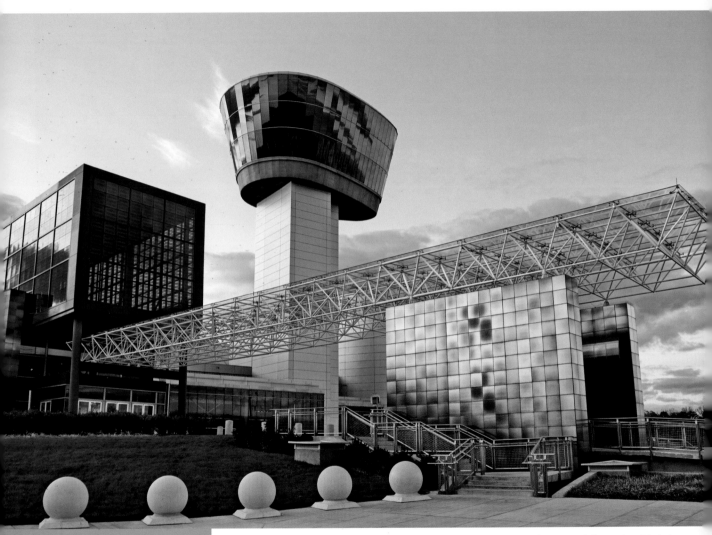

STEVEN F. UDVAR-HAZY CENTER With a 164-foot observation tower, two huge exhibition hangars, IMAX® theater, and the National Aviation and Space Exploration Wall of Honor, the Udvar-Hazy Center offers an inspiring museum experience. Located in Chantilly, Virginia, near Dulles Airport, the Center houses the majority of the Museum's aircraft and spacecraft, as well as numerous collections of flight-related artifacts.

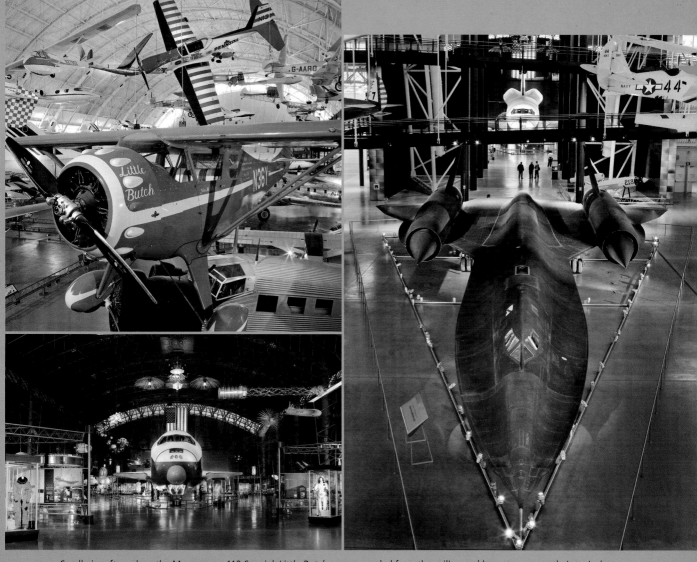

CLOCKWISE: Small aircraft, such as the Monocoupe 110 Special *Little Butch*, are suspended from the ceiling and hung to suggest their typical in-flight maneuvers. On its last flight, this Lockheed SR-71 Blackbird set a speed record by flying from Los Angeles to Washington, D.C., in 64 minutes, 20 seconds. The first space shuttle, *Enterprise*, dominates the James S. McDonnell Space Hangar.

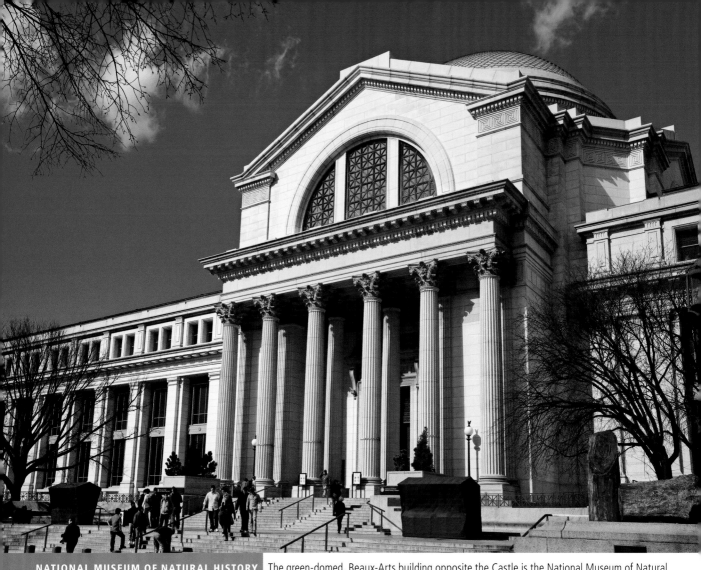

NATIONAL MUSEUM OF NATURAL HISTORY The green-domed, Beaux-Arts building opposite the Castle is the National Museum of Natural History. This well-known landmark houses more than 126 million natural and cultural objects. It is also the nation's largest research facility, offering scholars an opportunity to explore valuable resources in the fields of earth science, biology, and human origins.

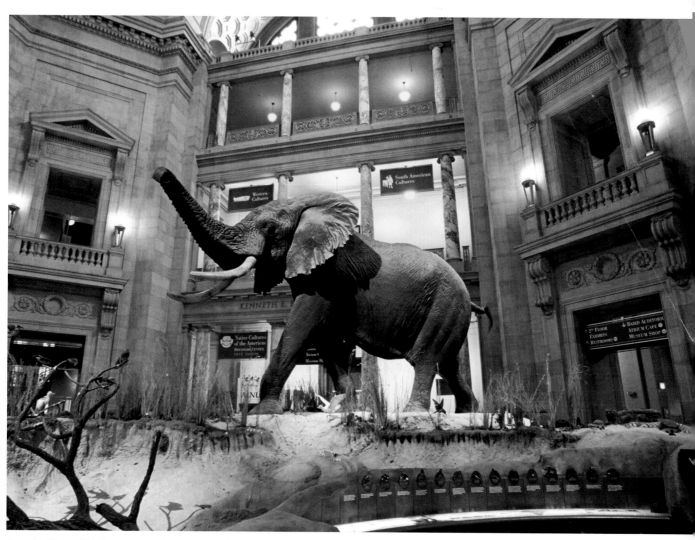

From the National Mall entrance, visitors step into the eight-sided, four-story Kenneth E. Behring Family Rotunda, with its dramatic arches and elegant marble balconies. The Fénykovi elephant, the largest mounted elephant in the world, dominates this grand space. He towers over a diorama of the natural habitat in his native Angola.

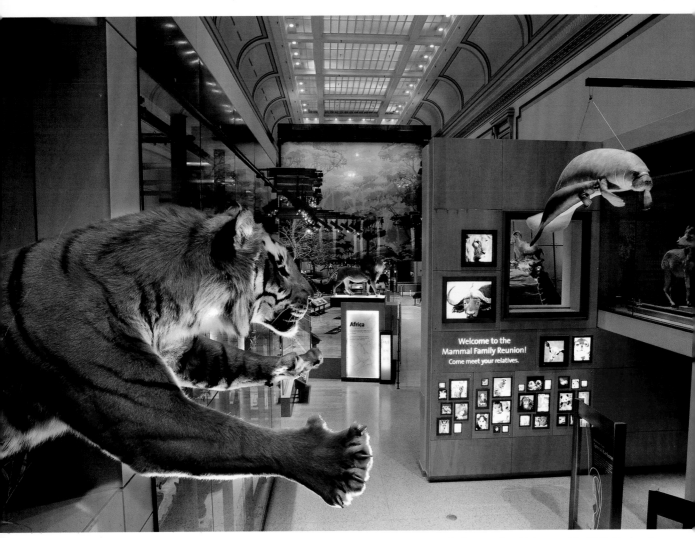

This leaping tiger is one of 274 species of mammals on exhibit in the Kenneth E. Behring Family Hall of Mammals, which opened in 2003. Tracing the story of mammals from their early ancestors, the galleries transport visitors from the grasslands of Africa to the Amazonian rain forests to convey how mammals adapt to diverse environments.

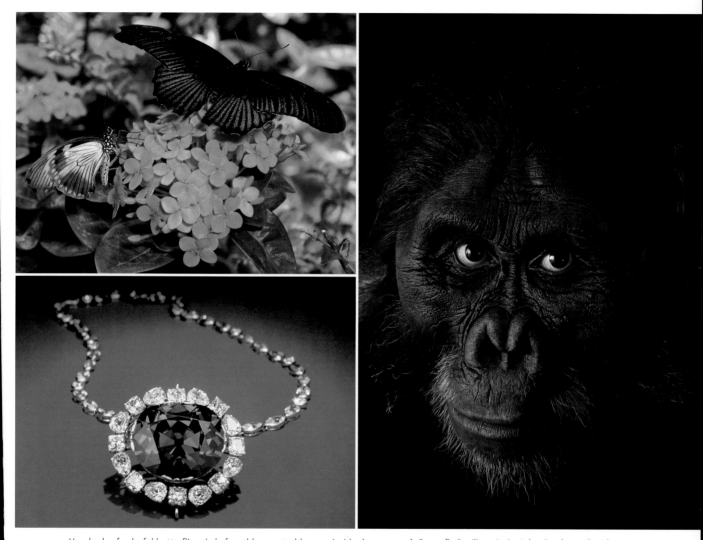

CLOCKWISE: Hundreds of colorful butterflies circle from blossom to blossom inside the museum's Butterfly Pavilion. Artist John Gurche sculpted this very lifelike face of our early ancestor for the David H. Koch Hall of Human Origins. The star of the Janet Annenberg Hooker Hall of Geology, Gems, and Minerals is the 45.52-carat Hope Diamond, the largest blue diamond in the world.

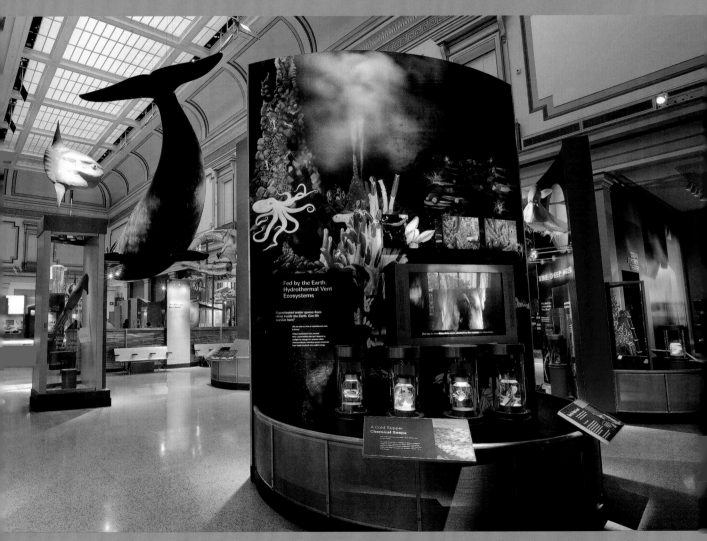

Phoenix, a model of an actual 2,200-pound North Atlantic right whale, is suspended above the Sant Ocean Hall, which features an ongoing exhibition about the magnificent water system that covers our planet. Visitors can see fossils and specimens of ocean life, view a video of the ocean floor, and use interactive displays to learn more about ocean ecosystems and exploration.

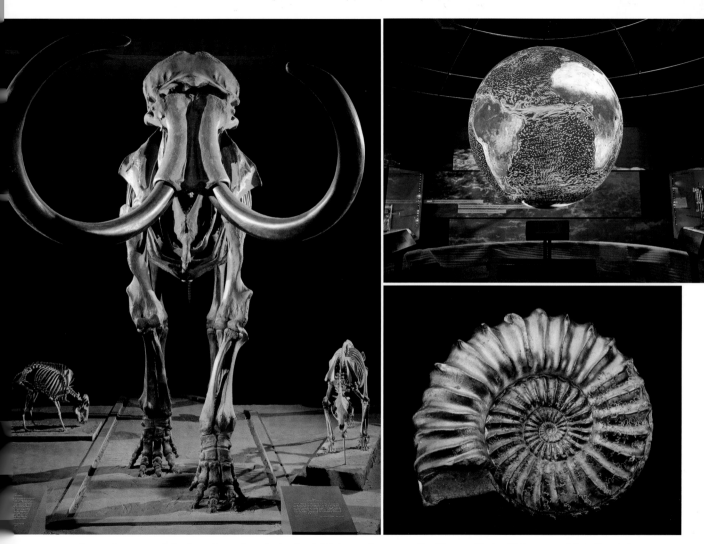

CLOCKWISE: Among the museum's fossil specimens from the Ice Age is this impressive mammoth with curved tusks. "Science on a Sphere," created by the National Oceanic and Atmospheric Administration (NOAA), is a popular multimedia display in the Sant Ocean Hall. Ammonites were marine animals that became extinct about 65 million years ago.

NATIONAL MUSEUM OF AMERICAN HISTORY The spacious galleries of the National Museum of American History, Kenneth E. Behring Center, showcase collections on America's technological, political, social, and cultural history. "Artifact walls" on the first and second floors display selections from the museum's three million objects. A welcome center near the National Mall entrance offers information about tours and programs.

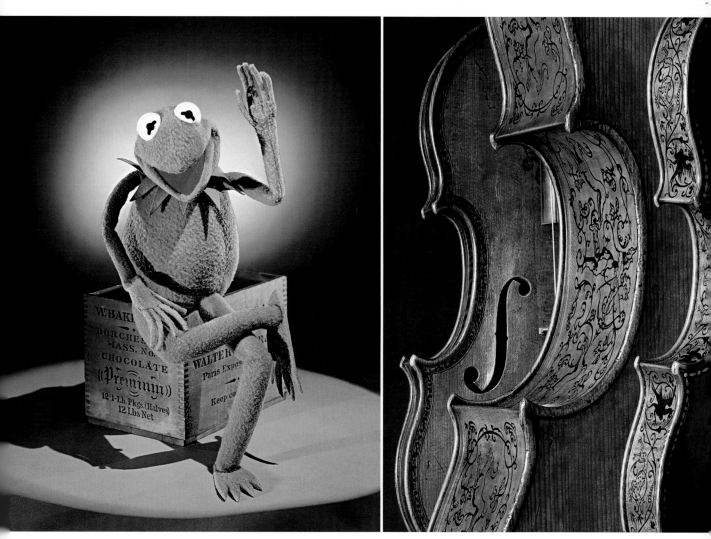

LEFT TO RIGHT: Among the popular artifacts at American History is Kermit the Frog. Jim Henson created this endearing Muppet for the TV show *Sesame Street*. The music division has many rare instruments, but the most exceptional is the eighteenth-century Stradivarius quartet of decorated instruments. The violin is regularly played in concert by the Smithsonian Chamber Music Society.

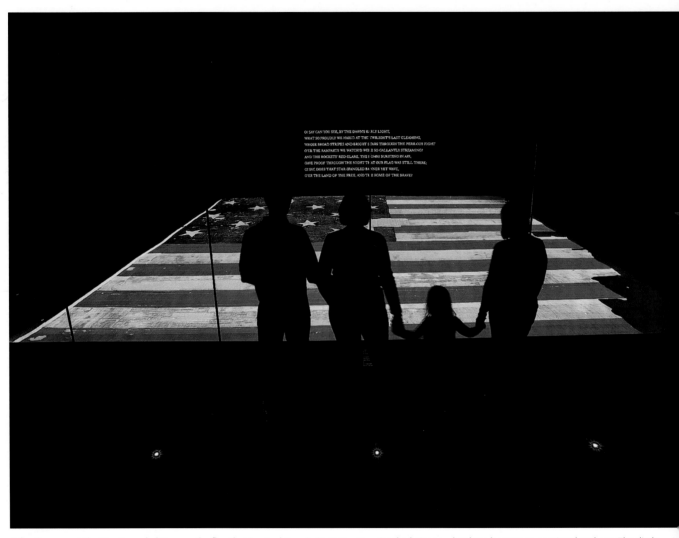

O! SAY CAN YOU SEE, BY THE DAWN'S EARLY LIGHT,
WHAT SO PROUDLY WE HAIL'D AT THE TWILIGHT'S LAST GLEAMING,
WHOSE BROAD STRIPES AND BRIGHT STARS THROUGH THE PERILOUS FIGHT
O'ER THE RAMPARTS WE WATCH'D WERE SO GALLANTLY STREAMING?
AND THE ROCKETS' RED GLARE, THE BOMBS BURSTING IN AIR,
GAVE PROOF THROUGH THE NIGHT THAT OUR FLAG WAS STILL THERE;
O! SAY, DOES THAT STAR-SPANGLED BANNER YET WAVE,
O'ER THE LAND OF THE FREE, AND THE HOME OF THE BRAVE?

A family gazes at the Star-Spangled Banner, the flag that inspired Francis Scott Key to write the lyrics to what later became our national anthem. The dimly lit gallery evokes the "dawn's early light" referred to in Key's verse. The exhibit also relates the history of the flag and the steps taken to preserve it.

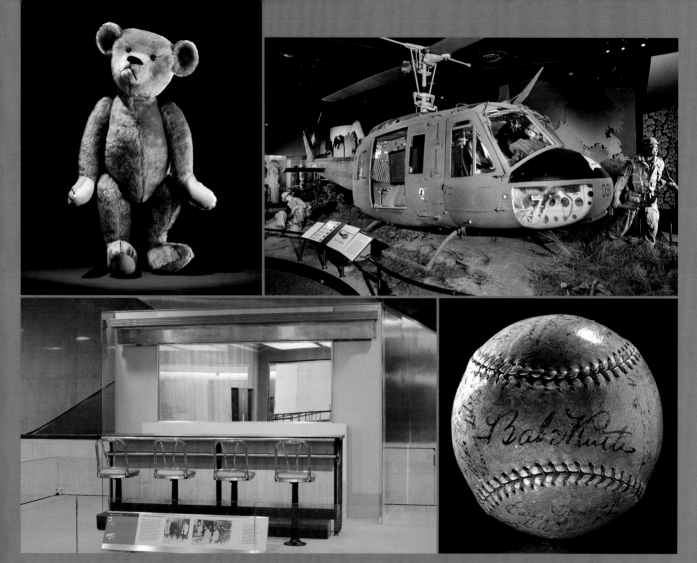

CLOCKWISE: The Ideal Toy Company created this teddy bear, named after President Theodore Roosevelt, in 1903. This Bell UH-1 Iroquois "Huey" helicopter served the 173rd Assault Helicopter Company during the Vietnam War. In 1960, a group of African American students in Greensboro, North Carolina, staged a sit-in at this lunch counter. Rare sports memorabilia include this Babe Ruth baseball.

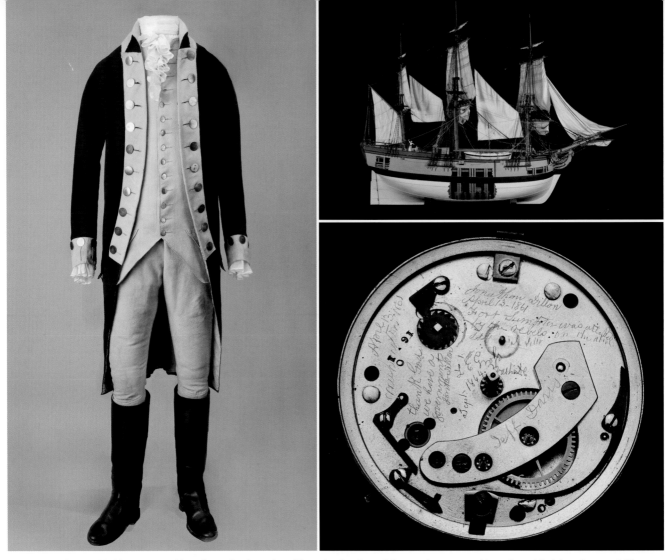

CLOCKWISE: George Washington wore this uniform after he resigned from the Continental Army to become president. A model of the schooner *Brilliant* is among the maritime objects in the "On the Water" exhibition. Jonathan Dillon was repairing Abraham Lincoln's watch when he learned that the first shots of the Civil War had been fired at Fort Sumter. He took the liberty of engraving a hopeful message inside the watchcase.

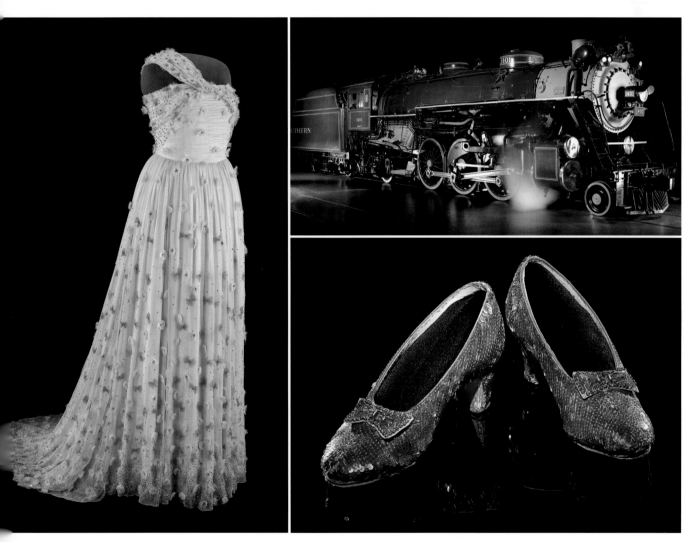

CLOCKWISE: The First Ladies exhibition includes this elegant Jason Wu gown, which Michelle Obama wore to the inaugural balls in 2009. A green steam locomotive, the 1401, built in 1926, pulled passenger trains at up to 80 miles per hour on the Southern Railway's Charlotte Division. Judy Garland wore these sparkling ruby slippers during the filming of the classic movie *The Wizard of Oz*.

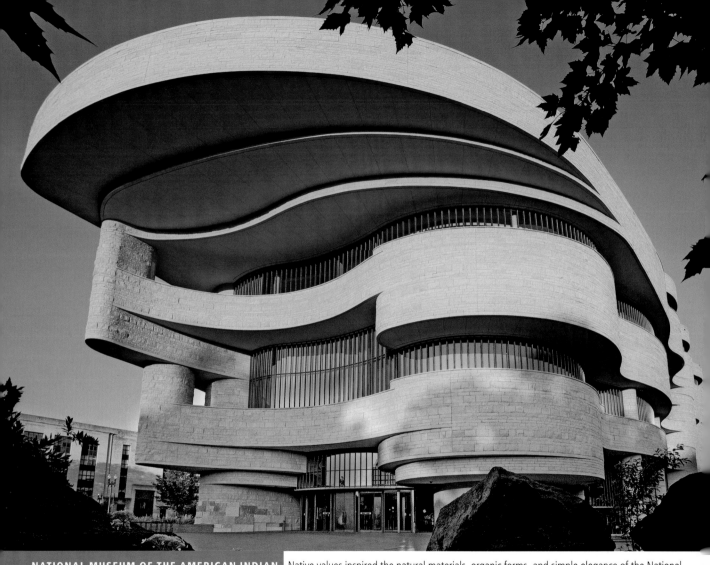

NATIONAL MUSEUM OF THE AMERICAN INDIAN Native values inspired the natural materials, organic forms, and simple elegance of the National Museum of the American Indian building on the National Mall. The museum is dedicated to advancing knowledge about the histories, cultures, and arts of Native peoples of the Americas. The grounds include 150 species of indigenous plants and more than 25 native tree species as well as a water feature.

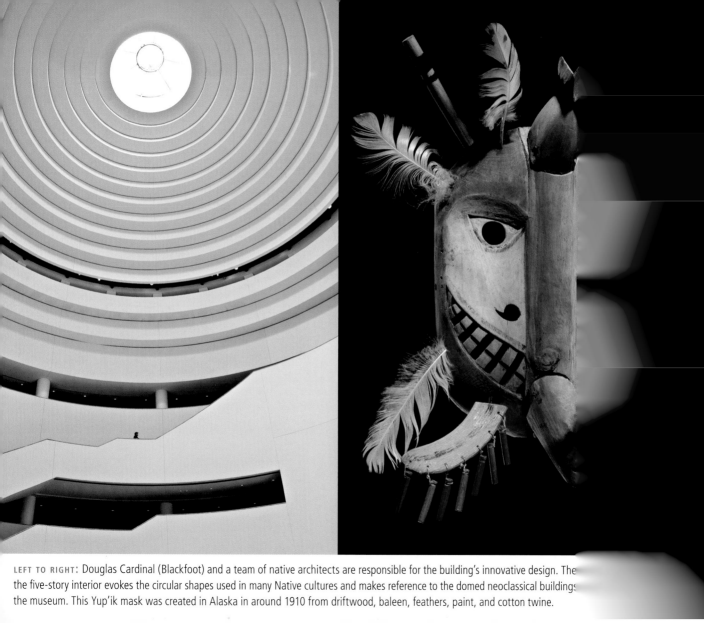

LEFT TO RIGHT: Douglas Cardinal (Blackfoot) and a team of native architects are responsible for the building's innovative design. The
the five-story interior evokes the circular shapes used in many Native cultures and makes reference to the domed neoclassical buildings
the museum. This Yup'ik mask was created in Alaska in around 1910 from driftwood, baleen, feathers, paint, and cotton twine.

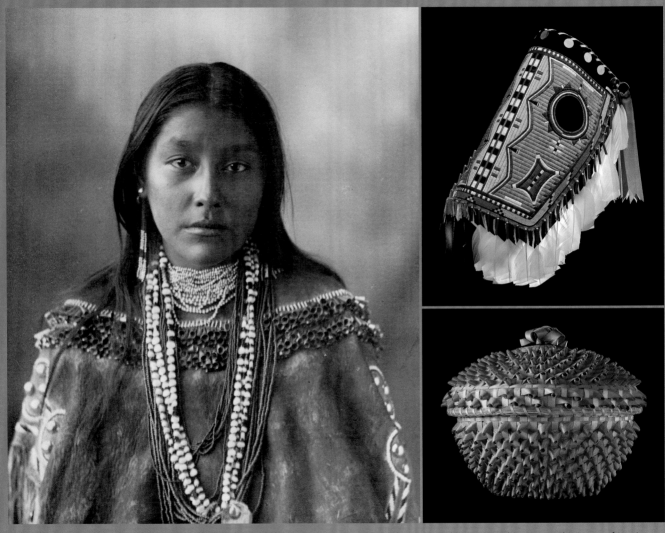

CLOCKWISE: The museum has a photographic archive that documents Native cultures from the nineteenth century to the present. This image of Hattie Tom, Chiricahua Apache, was taken in Omaha, Nebraska, ca. 1898. Works by contemporary Native artists include an intricately beaded horse mask by Juanita Growing Thunder Fogarty (Assiniboine/Sioux) and an elaborate wicker strawberry basket by Mary Adams (Akwesasae Mohawk).

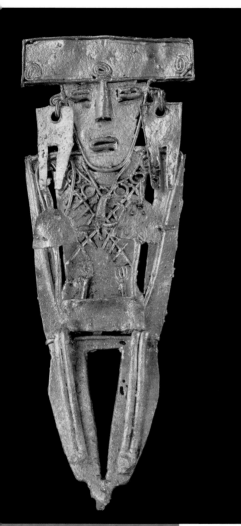

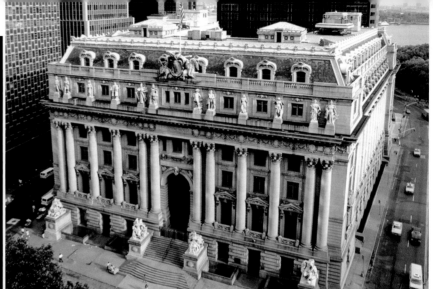

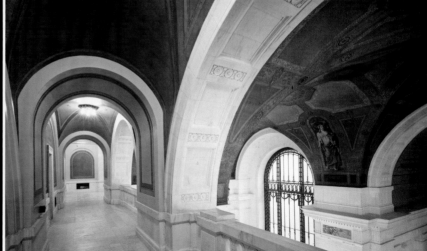

GEORGE GUSTAV HEYE CENTER The George Gustav Heye Center (top right) in New York City is a branch of the National Museum of the American Indian. It occupies the Alexander Hamilton U.S. Custom House, a splendid example of Beaux-Arts architecture. The building's grand spaces (bottom right) are used for exhibitions and educational programs. A gold ornament from Colombia (left) dates from A.D. 1000–1500.

29

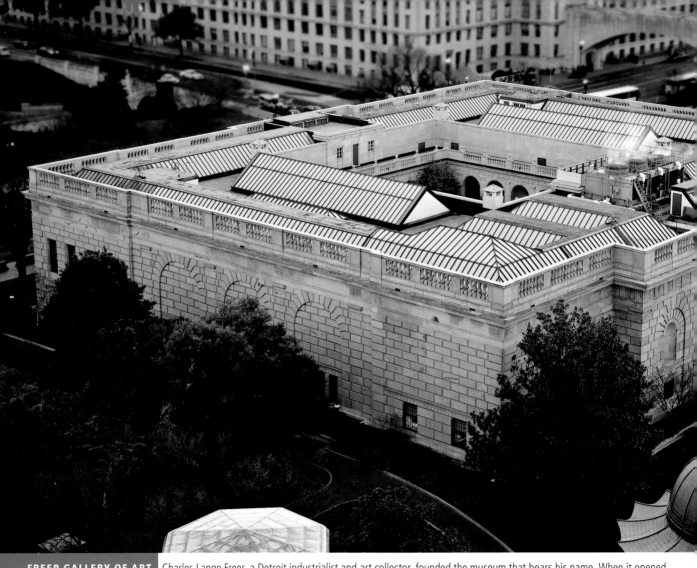

FREER GALLERY OF ART Charles Lange Freer, a Detroit industrialist and art collector, founded the museum that bears his name. When it opened in 1923, it was the first Smithsonian museum of fine arts. The unusual combination of Asian and American masterworks in the collection reflects Freer's personal tastes. Within the walls of the marble Italian Renaissance–style building, designed by architect Charles Platt, is the largest group of works by

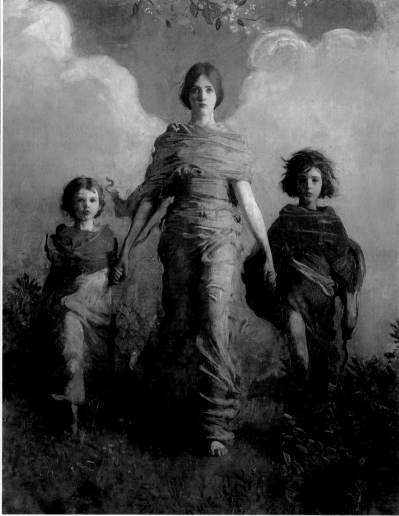

James McNeill Whistler; Chinese, Japanese, Korean, South and Southeast Asian art; ancient Egyptian art; and samples of early Christian art. Among the nineteenth- and twentieth-century paintings is Abbot Handerson Thayer's lovely *A Virgin*, based on the Louvre's classic marble scuplture, *Winged Victory*.

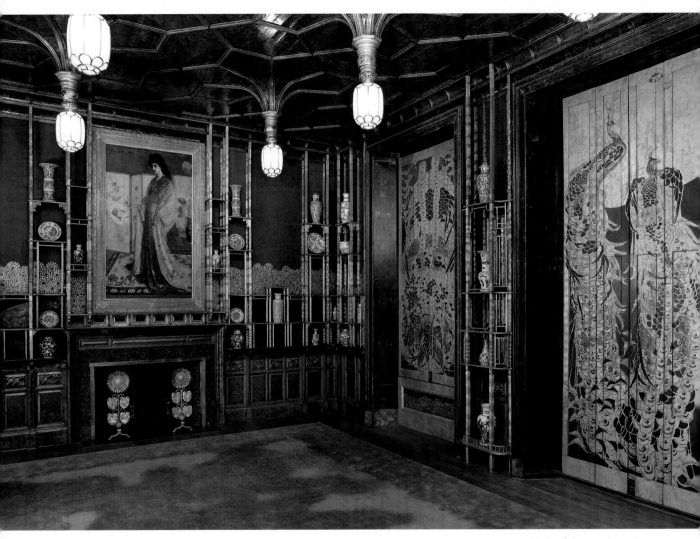

Harmony in Blue and Gold: The Peacock Room is James McNeil Whistler's only existing interior design scheme and a highlight of the Freer's permanent collection. The painting at the center of the gilded room is Whistler's *The Princess from the Land of Porcelain*. It is seen here surrounded by fine examples of blue-and-white Kangxi porcelain. Depictions of fighting peacocks grace the far walls.

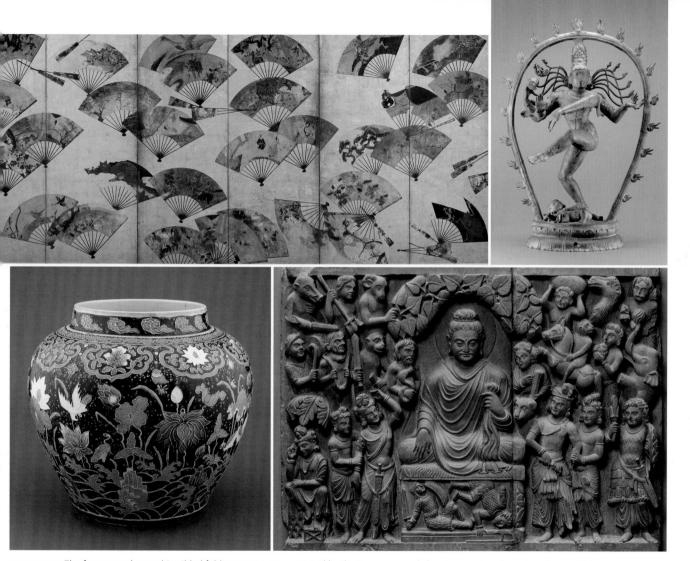

CLOCKWISE: The fans pasted onto this gilded folding screen were painted by the Tawaraya workshop in seventeenth-century Japan. *Shiva as Nataraja, Lord of the Dance* from India, c. 990, shows the deity dancing the world into existence. *Four Scenes from the Life of the Buddha* once adorned a second- or third-century CE stupa. A Fahua jar from the Ming Dynasty depicts aquatic scenes in rich shades of cobalt blue and turquoise.

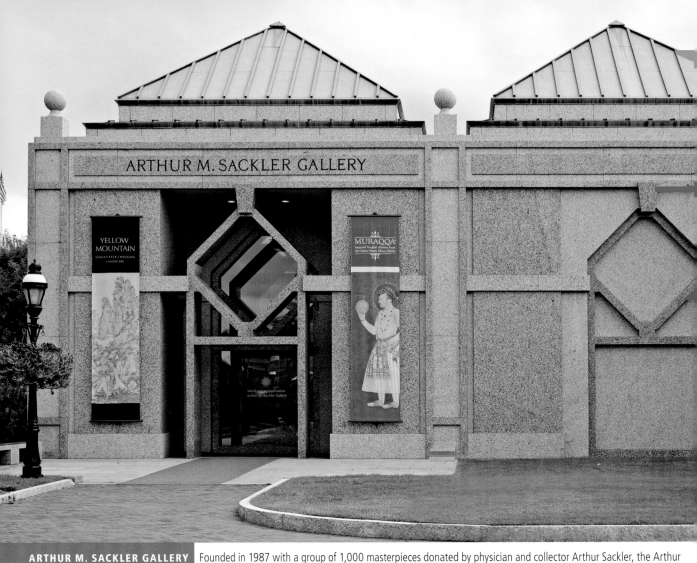

ARTHUR M. SACKLER GALLERY Founded in 1987 with a group of 1,000 masterpieces donated by physician and collector Arthur Sackler, the Arthur M. Sackler Gallery explores Asia's traditions through artworks that range from ancient times to the present. The gallery also presents exhibitions from international venues, such as Japan, Korea, China, Indonesia, and India. Its programs of music, dance, and film invite visitors to explore Asian cultures.

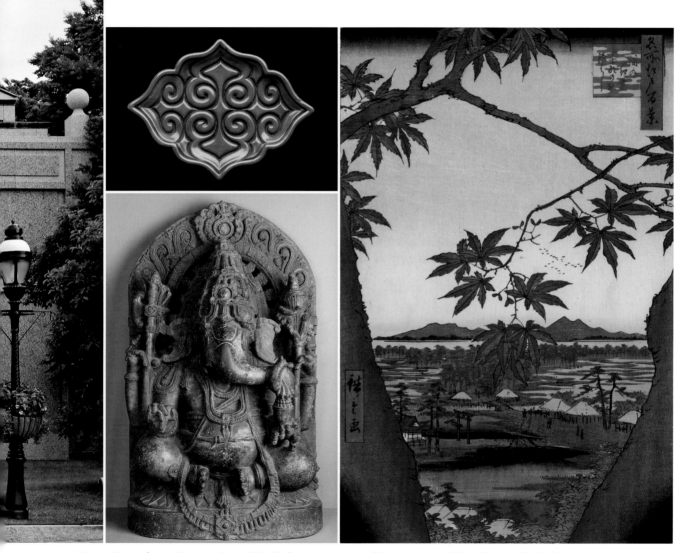

CLOCKWISE: Intricate objects of carved lacquered wood like this fourteenth-century dish were prized in China. This woodblock print is among the colorful landscape and genre scenes from Utagawa Hiroshige's *One Hundred Famous Views of Edo* from 1857. Elephant-headed Ganesha is the god of new beginnings and remover of obstacles.

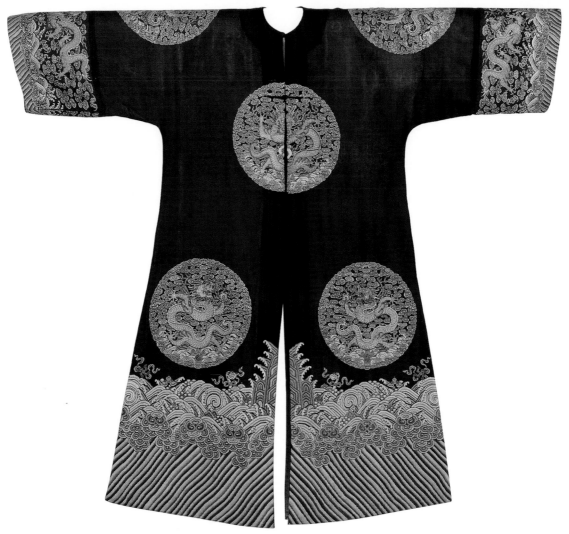

During the Qing Dynasty in mid-nineteenth-century China, a noblewoman of the Imperial household wore this silk surcoat. It is embroidered with eight dragon roundels. The total number of roundels and the number of dragons' claws indicate that the wearer was of high rank in court. The surcoat was worn over flowing court robes.

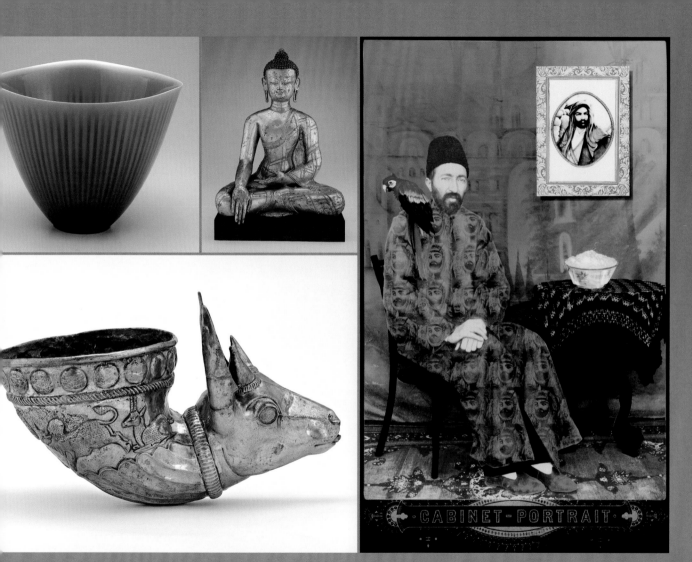

CLOCKWISE: Japanese artist Miyanishi Atsushi crafted this deep cobalt-blue porcelain bowl with linear design in 1991. The Sackler's sublime Seated Buddha once graced the altar of a Buddhist monastery in Tibet. Iranian artist Malikeh Nayani used digital technology to produce the vividly colored portrait *Untitled Grandfather* in 1997. Made of silver and gilt, a rare drinking horn dates from the reign of the Sasanian in Iran.

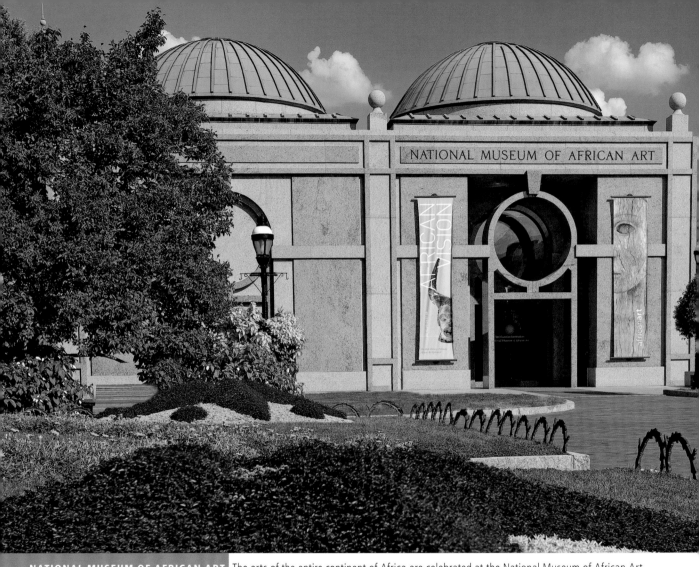

NATIONAL MUSEUM OF AFRICAN ART The arts of the entire continent of Africa are celebrated at the National Museum of African Art. Visitors can see fine examples of masks, sculpture, painting, architectural elements, photographs, and multimedia from diverse cultures. The museum's permanent collection includes more than 9,000 objects, among which is the Walt Disney-Tishman African Collection, which contains 525 works of art.

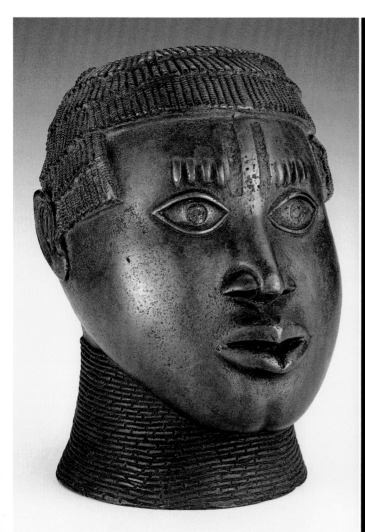
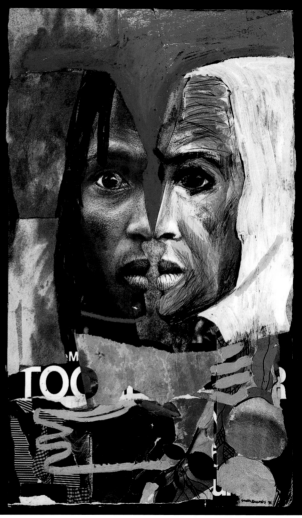

LEFT TO RIGHT: An impressive bronze head is the work of the Edo peoples of the Benin Kingdom, Nigeria. It dates from the fifteenth to sixteenth century. The museum's Sylvia H. Williams Gallery for contemporary African art showcases the work of many talented artists. Among them is Garth Erasmus, a multimedia artist from South Africa and creator of the provocative *Muse #3*.

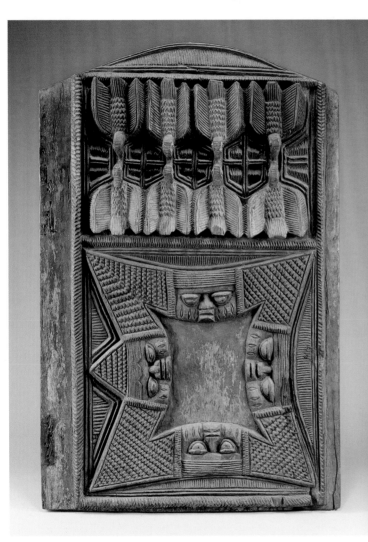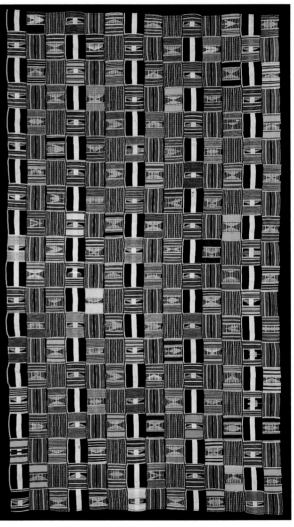

LEFT TO RIGHT: Olowe of Ise from Nigeria fashioned this door in the early twentieth century. In the lower portion is a divination board, which depicts the four faces of Eshu, the messenger god and god of change. The museum has a large collection of textiles, including excellent examples of weaving, such as this multicolored geometric wrapper from Ghana.

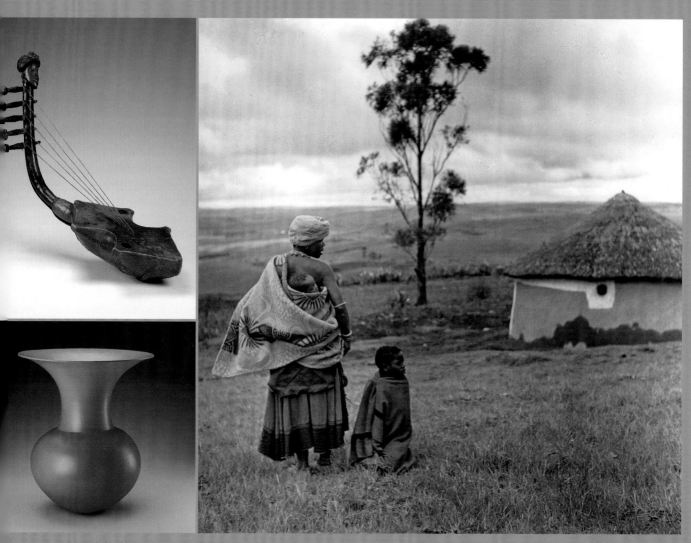

CLOCKWISE: Made by the Zande people of the Democratic Republic of the Congo, this harp has a beautifully carved head. The museum's Eliot Elisofon Archives contains over 350,000 items, including this photograph of a Transkei woman with her children, taken in 1947 by Constance Stuart Larrabee. Kenyan artist Magdalene Anyango N. Odundo crafted the elegant ceramic vessel *Untitled #1*.

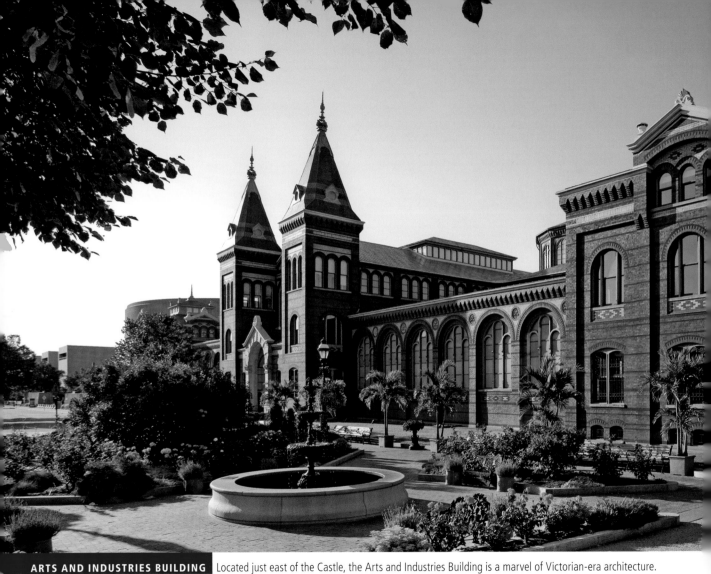

ARTS AND INDUSTRIES BUILDING Located just east of the Castle, the Arts and Industries Building is a marvel of Victorian-era architecture. The building opened in 1881, just in time to serve as the setting for President James Garfield's inaugural ball. Prior to construction of the newer museums on the National Mall, the Arts and Industries' three large halls accommodated collections as diverse as First Ladies' gowns to early airplanes. It also housed

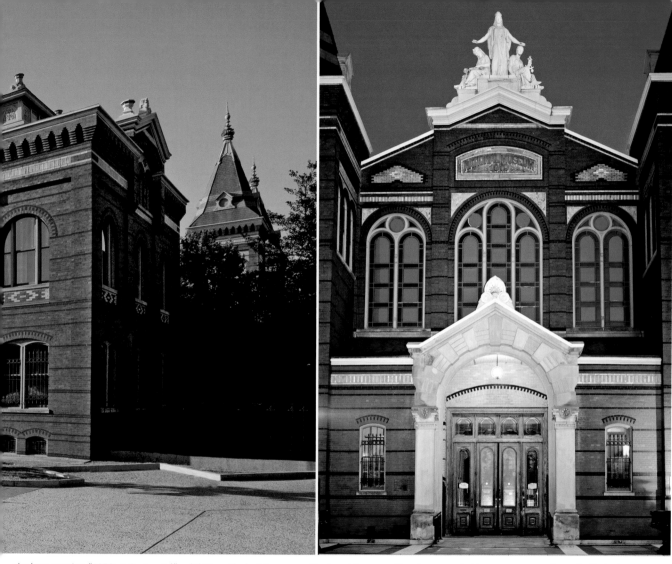

the long-running "1876: A Centennial" exhibition. The building, currently closed for renovation, is surrounded by sumptuous gardens: the Katherine Dulin Folger rose garden (seen in front), the Mary Livingston Ripley Garden to the east, and the Enid A. Haupt Garden to the west.

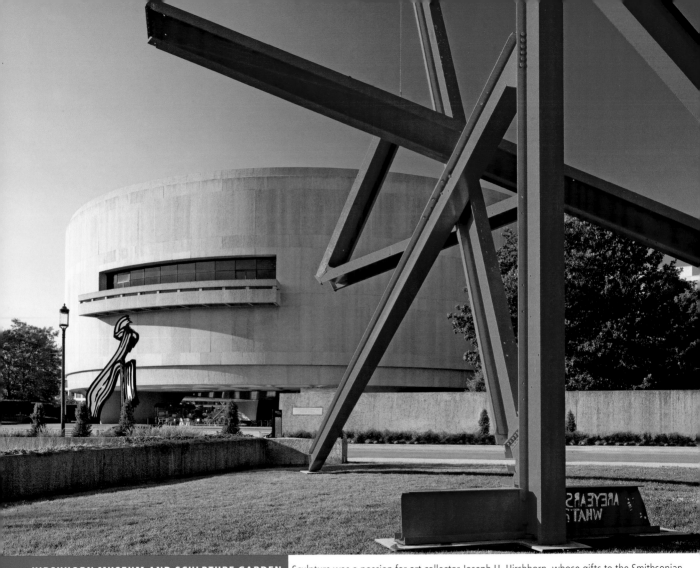

HIRSHHORN MUSEUM AND SCULPTURE GARDEN Sculpture was a passion for art collector Joseph H. Hirshhorn, whose gifts to the Smithsonian of more than 12,000 works form the basis of the Hirshhorn Museum and Sculpture Garden's collection. The monumental works of artists Roy Lichtenstein (background) and Mark di Suvero (foreground) flank the building. The museum is committed to exhibiting works in all media.

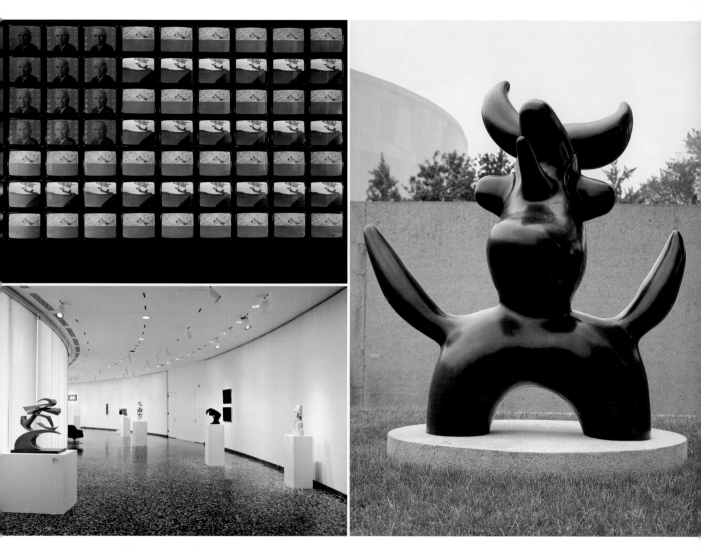

CLOCKWISE: Nam June Paik's remarkable *Video Flag* is a multimedia artwork comprised of seventy video monitors and various computer timers. The piece makes reference to American politics and the media. The whimsical *Lunar Bird*, by Spanish artist Joan Miró, dominates the Hirshhorn's sculpture garden. The museum's light-filled and gently curving galleries are filled with sculpture.

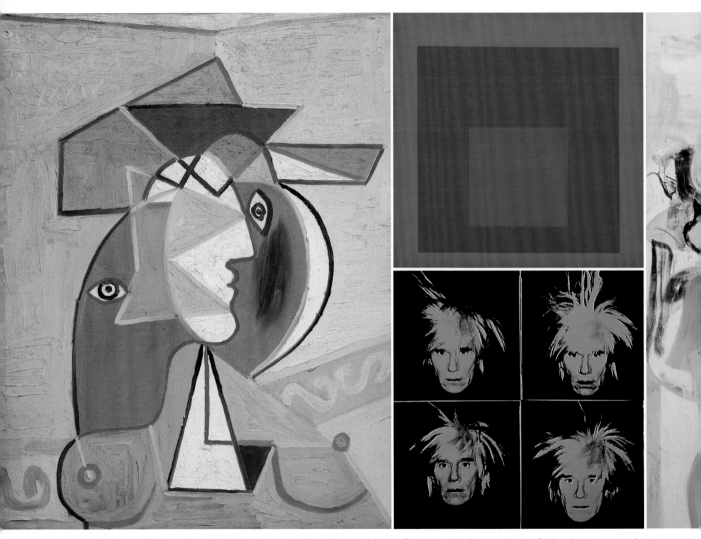

CLOCKWISE: Pablo Picasso's *Woman in a Hat (Marie-Therese Walter)* of 1934 celebrates femininity in brilliant color. Josef Albers's *Homage to the Square* series allowed the artist to explore the interaction of color on flat, concentric planes. Andy Warhol's *Self-Portrait* is a signature work by the leader of the Pop art movement.

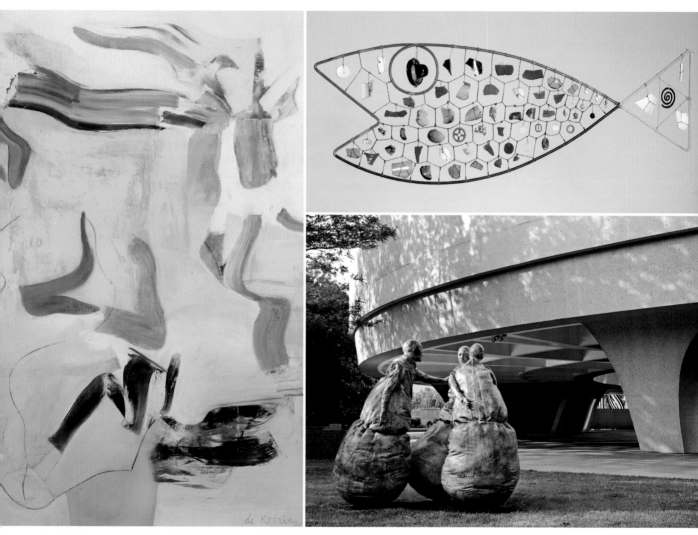

CLOCKWISE: The lyrical *Untitled III, 1981* is a late work by Dutch-born Willem de Kooning, a master of the Abstract Expressionist style. Known for his appealing works of simple shapes and primary colors, Alexander Calder executed this glittering *Fish* mobile in 1944. A group of three bronze figures by Juan Muñoz huddle on the Hirshhorn grounds.

47

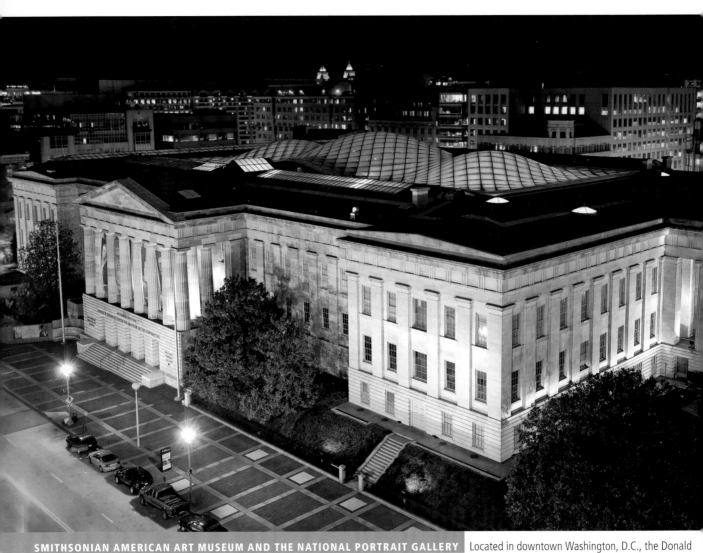

SMITHSONIAN AMERICAN ART MUSEUM AND THE NATIONAL PORTRAIT GALLERY Located in downtown Washington, D.C., the Donald W. Reynolds Center for American Art and Portraiture occupies the Patent Office Building, which is a National Historic Landmark. The Greek Revival building houses the collections of both the Smithsonian American Art Museum and the National Portrait Gallery. The museums share the glass-walled Lunder

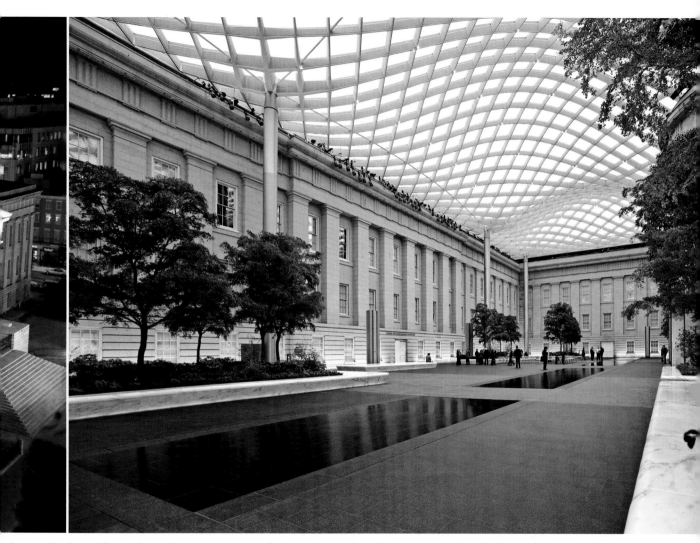

Conservation Center. The undulating glass canopy above the Robert and Arlene Kogod Courtyard was designed by Foster + Partners. Made of steel, glass, and aluminum, it joins the two museum spaces and provides a dramatic setting for concerts and special programs.

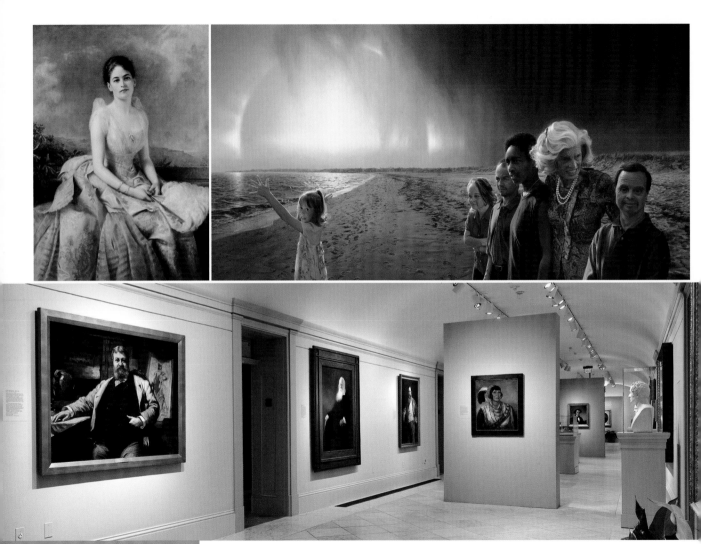

NATIONAL PORTRAIT GALLERY Faces of those who forged our nation's history, as well as those who continue to leave their mark, form the collections of the National Portrait Gallery. Years after she posed for this grand portrait in 1887, Juliette Gordon Low (left) founded the Girl Scouts of America. David Lenz, a portrait competition winner, depicted Eunice Kennedy Shriver, founder of Special Olympics, with Special Olympic athletes and a Best Buddy (right).

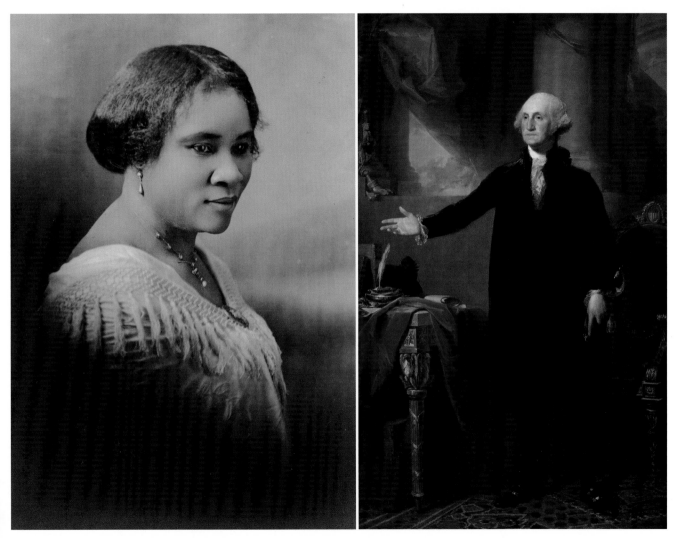

LEFT TO RIGHT: Photographer Addison Scurlock took this trademark portrait of Madame C. J. Walker, whose line of hair products made her one of the most successful African American entrepreneurs of the early 1900s. Gilbert Stuart's famous "Lansdowne" portrait of President George Washington was saved from the burning White House during the British invasion of Washington in the War of 1812.

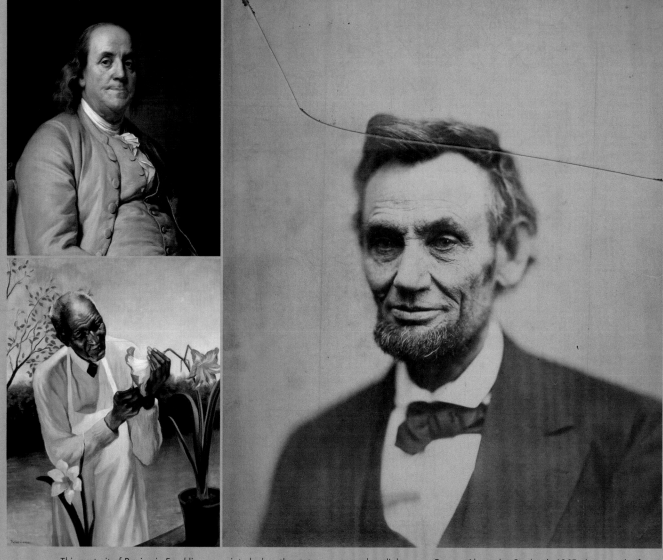

CLOCKWISE: This portrait of Benjamin Franklin was painted when the statesman served as diplomat to France. Alexander Gardner's 1865 photograph of Abraham Lincoln shows a war-weary president. The cracked glass plate came to symbolize the bullet that would shatter the president's life just a few weeks later. Though he was born a slave, George Washington Carver eventually became director of agricultural teaching and research at Alabama's Tuskegee Institute.

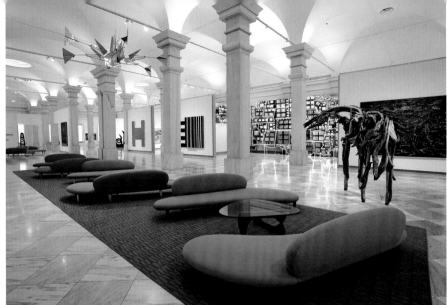

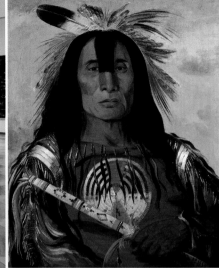

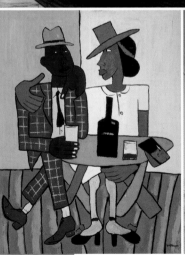

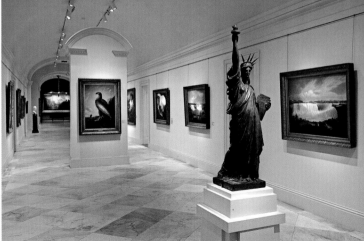

SMITHSONIAN AMERICAN ART MUSEUM Highlights of the Smithsonian American Art Museum collection's include (clockwise) contemporary art; paintings of the West, such as George Catlin's *Stu-met-o-súcks, Buffalo Bull's Back Fat, Head Chief, Blood Tribe*; nineteenth-century landscape painting; early modern paintings, such as William H. Johnson's *Café*; and modern sculpture, including Roy Lichtenstein's *Modern Head*.

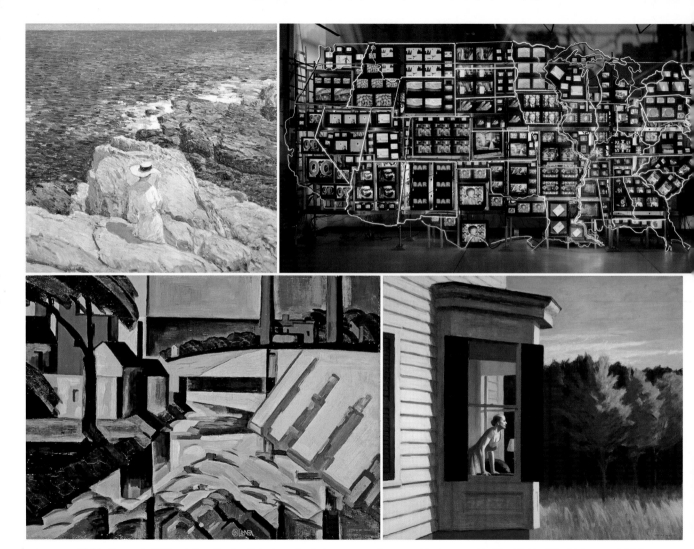

CLOCKWISE: Childe Hassam's 1913 painting *The South Ledges, Appledore* conveys the rugged textures and brilliant light of the Maine coast. Visitors are drawn to *Electronic Superhighway: Continental U.S., Alaska, Hawaii*, a 1995 video installation by Nam June Paik. The museum features work by 7,000 artists, including realist Edward Hopper, who painted *Cape Cod Morning*, and Oscar Bluemner, creator of the abstract canvas *Evening Tones*.

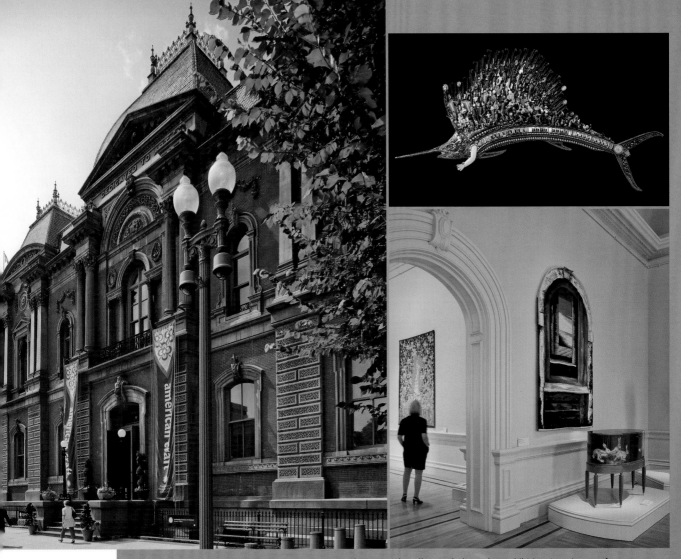

RENWICK GALLERY A branch of the Smithsonian American Art Museum, the Renwick Gallery is dedicated to exhibiting American crafts and decorative arts from the nineteenth-century to the present. It is situated a block from the White House. Larry Fuente's whimsical *Game Fish* is on permanent exhibit. One-of-a-kind pieces from American Art's permanent collection of contemporary craft are displayed on a rotating basis.

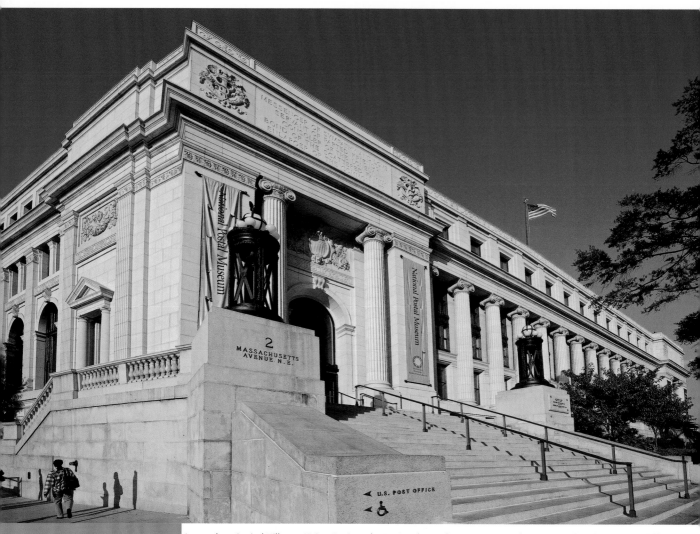

NATIONAL POSTAL MUSEUM Located on Capitol Hill near Union Station, the National Postal Museum opened in 1993 in the Old City Post Office Building. Designed by Daniel Burnham and built between 1911 and 1914, it is a classic example of Beaux-Arts architecture. The collection traces America's postal history through diverse objects, such as rare stamps, historic letters, Pony Express artifacts, carrier uniforms, stagecoaches, trains, and planes.

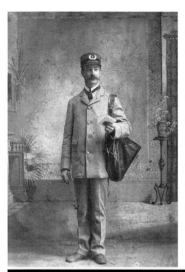

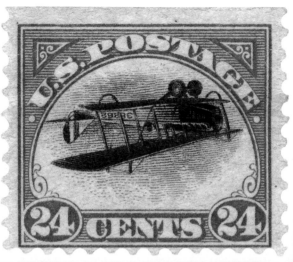

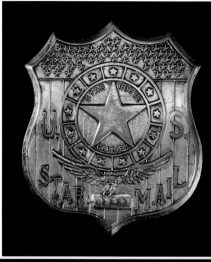

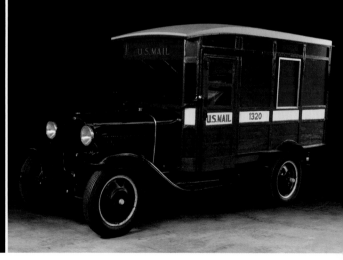

CLOCKWISE: A letter carrier in uniform had his studio portrait made in 1885. The central image of this rare 24-cent Curtiss Jenny stamp was printed upside down. A member of the National Star Route Carriers Association wore this badge when carrying mail. The postal service used Ford Model AA trucks to deliver parcel post from the 1930s through the 1950s. The young John Lennon owned this stamp album.

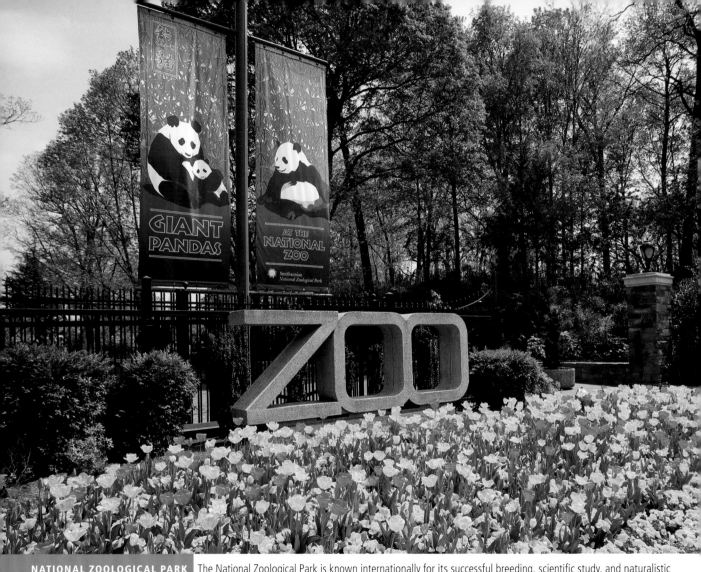

NATIONAL ZOOLOGICAL PARK The National Zoological Park is known internationally for its successful breeding, scientific study, and naturalistic display of wild animals. It is located on Connecticut Avenue in northwest Washington, D.C. The 163-acre park features vertebrate, invertebrate, and aquatic species in diverse exhibits, such as Amazonia, the Asia Trail, the Reptile Discovery Center, and Great Cats.

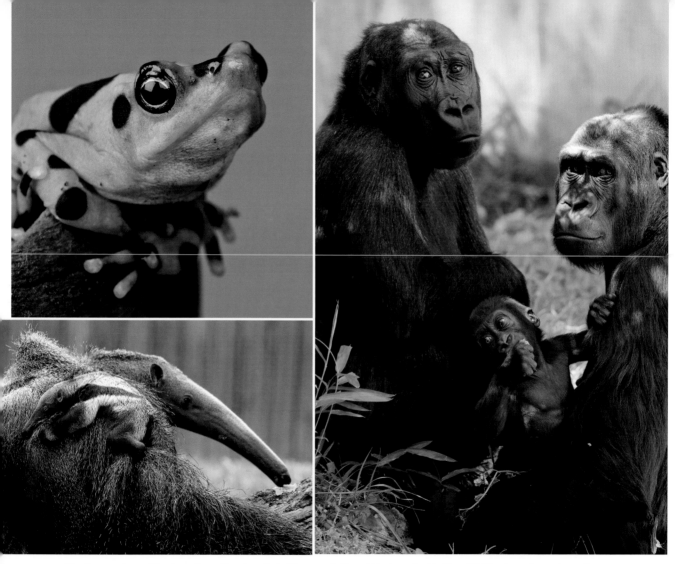

CLOCKWISE: The Panamanian golden frog, the national symbol of Panama, is thought to be extinct in the wild. Thanks to the zoo's captive-breeding program, this amphibian may be seen in the Reptile Discovery Center. In spring, visitors flock to the zoo to see newborns, such as this baby gorilla and tiny anteater, interacting with their protective parents.

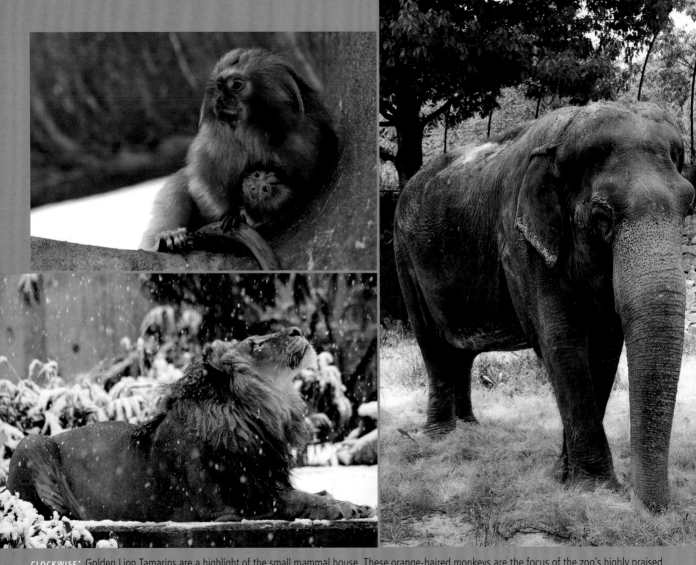

CLOCKWISE: Golden Lion Tamarins are a highlight of the small mammal house. These orange-haired monkeys are the focus of the zoo's highly praised conservation program. The zoo is also committed to conserving the Asian elephant. Indoor and outdoor elephant trails are being created to simulate the elephants' native habitat. A regal lion is among the extraordinary animals in the Great Cats exhibit.

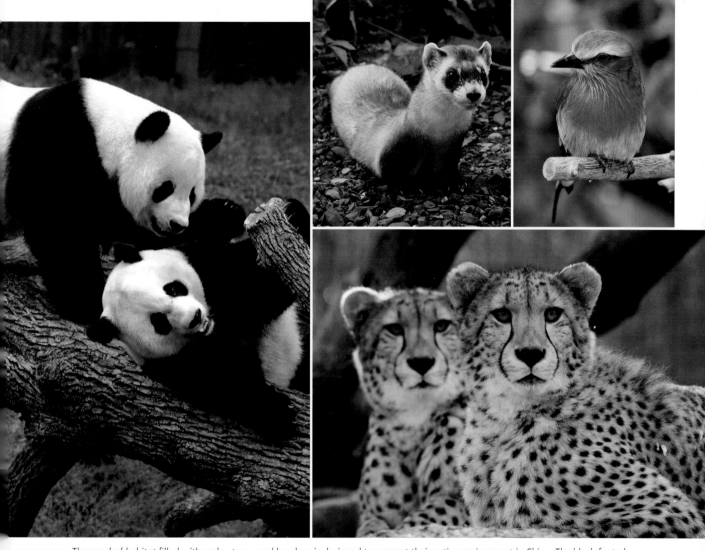

CLOCKWISE: The pandas' habitat filled with rocks, trees, and bamboo is designed to suggest their native environment in China. The black-footed ferret has a limber frame that allows it to dart after prey through tunnels burrowed below ground. The Lilac Breasted Roller, from Africa, "rolls" its body when in courtship. The Cheetah Conservation Station studies and breeds this endangered animal.

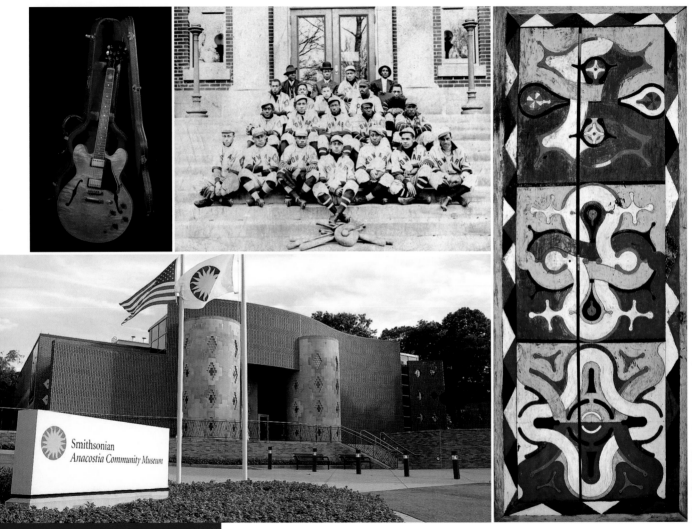

ANACOSTIA COMMUNITY MUSEUM The Anacostia Community Museum is dedicated to the research, documentation, and interpretation of urban contemporary communities and issues. Highlights of the diverse collection include a guitar owned by Chuck Brown, the leading innovator of Go-Go music, an archival photograph of the Howard University baseball team, and a Maroon door from Suriname.

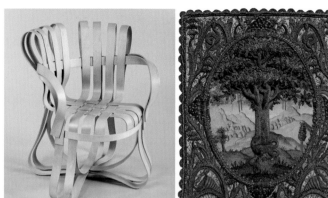

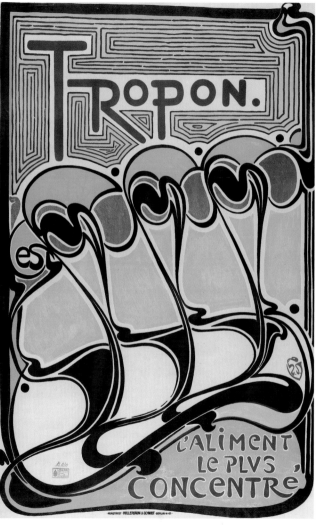

COOPER-HEWITT, NATIONAL DESIGN MUSEUM Housed in the magnificent Andrew Carnegie mansion on Fifth Avenue in New York City, the Cooper-Hewitt, National Design Museum is devoted to historic and contemporary design. The 1994 Cross-check chair by Frank Gehry, a silk panel from seventeenth-century France, and an Art Nouveau poster from Belgium are highlights of the collection.

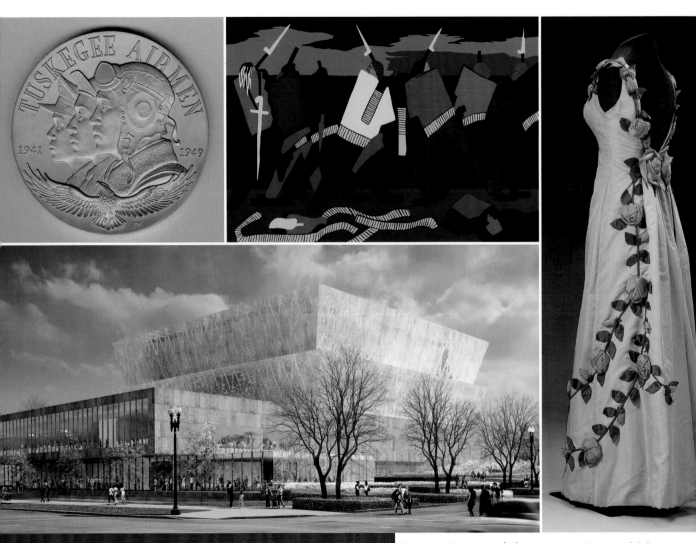

NATIONAL MUSEUM OF AFRICAN AMERICAN HISTORY AND CULTURE The National Museum of African American History and Culture documents African American life. Among the museum's collections is a medal of the Tuskegee Airmen, a painting from Jacob Lawrence's series *The Migration of the Negro*, and the American Beauty Dress, by Anne Lowe. Founded in 2003, the museum's building is scheduled to open in 2015.

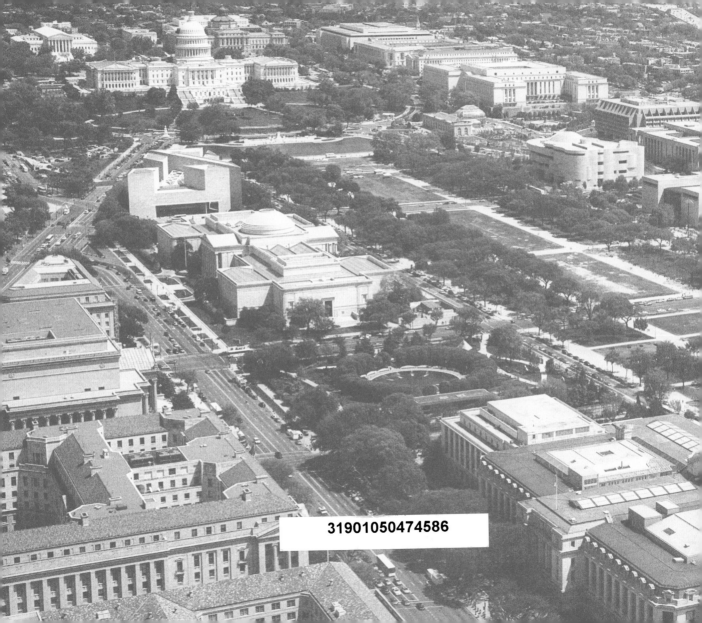